Adult Coloring book Arizona Summer & Desert Life
Vol 7
By: L. M. Boelz

I want to take a moment to thank you for purchasing this coloring book. A lot of time went into the making of it. I wanted to be able to give you hours of fun and relaxation. So Enjoy. Be sure to check out my other coloring books if you like this one. There are 20 different pictures to color in this book.

Other titles

Southwest, Floral

Chickens

Zen Eggs

Dragons Fantasy

Day of the Dead & Mardi Gras

Farm Animals

Copy Right July 12 2016
Please enjoy, be creative and think outside the box. You can color traditional or go wild with colors. The pages are one sided which allows you to frame them if you so desire. You can use pencils, markers or fine tipped pens. If using a marker or ink place something between the pages to prevent the color from bleeding through to the next page.
All Rights Reserved, Including The Right Of Reproduction In Whole Or In Part In Any Form.
This -Book Is Licensed For Your Personal Enjoyment Only. No pictures can be copied and resold, rented or least in any form. The Author Holds All Reproduction, Reprint Or Re -Sell Rights To This Book In Digital, Audio Or Print Versions.

pages

Bluffs…………………………….............…..	1
Vulture……... ………..................................……..…	2
Hen on nest…………...…................................…….	3
Sedona………………………..….............................	4
Winding Road…………………………………….…	5
Hydrant & Dog………………………………………	6
Ducks………………………………………………….	7
Hot Barrel Cacti……………………………...…….	8
Agave………………………….……………………….	9
Hot Cacti …………………………...…………………..	10
Hot Summer Sun …………………………………….	11
Deadwood…………………………………………...…	12
Dancers……………………………………………….	13
Bones…………………………………………………...	14
Cow Skull…………………...………………………..	15
Gila………………………………………………….…	16
Desert……………………………………………….…	17
Saloon …………………………………………………	18
Danger………………………………………………..	19
Prickly Pear……………………………………….…	20

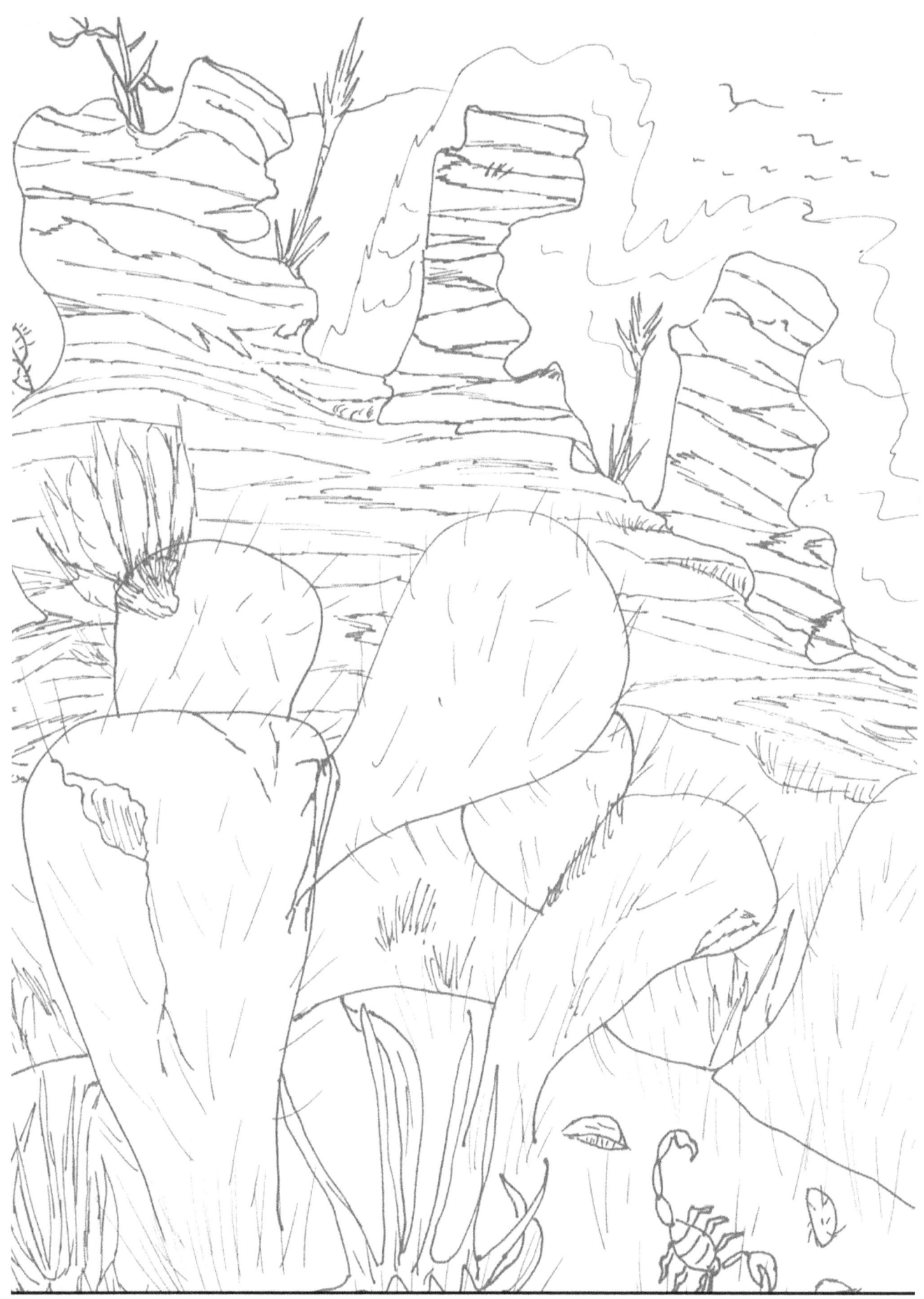

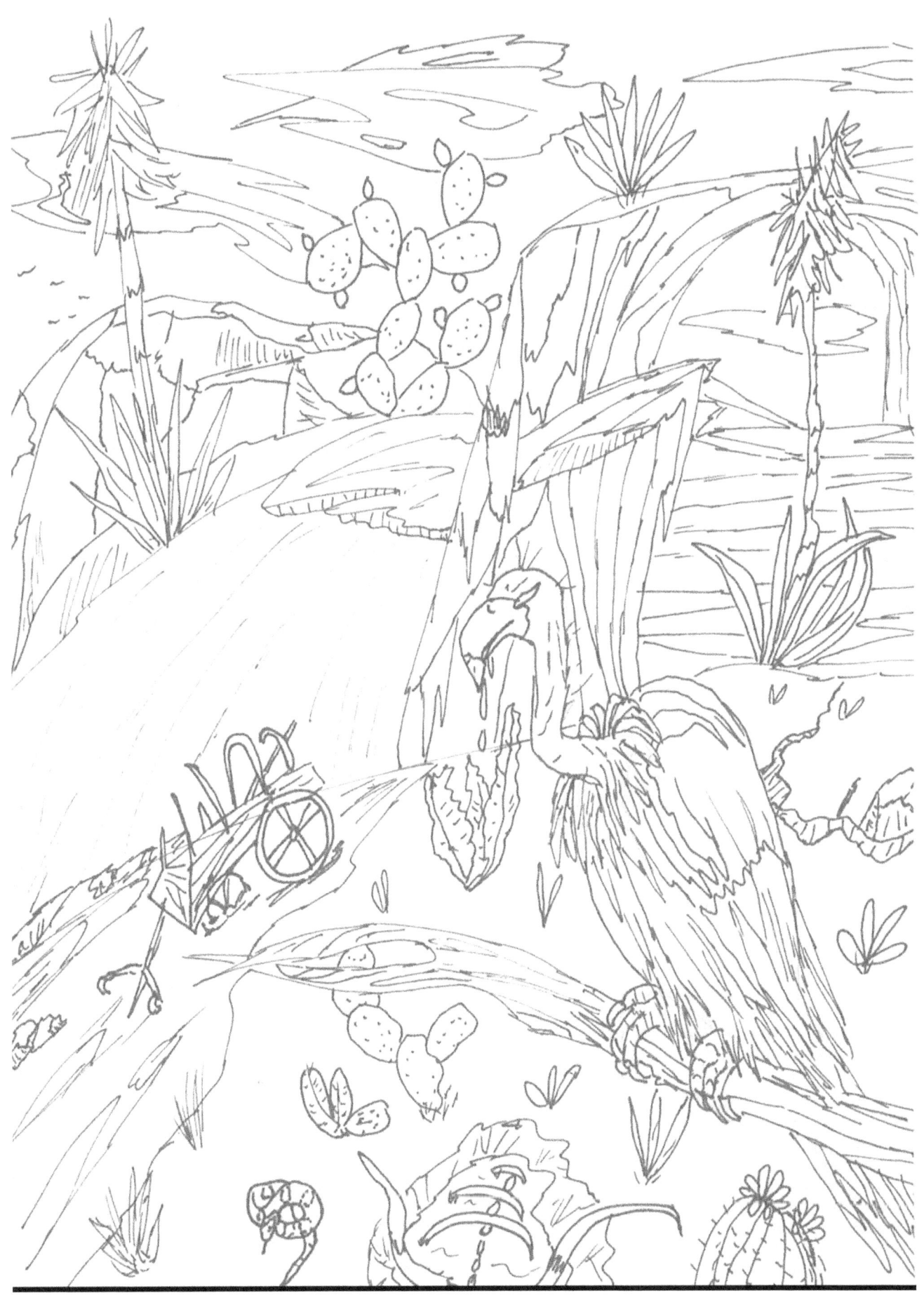

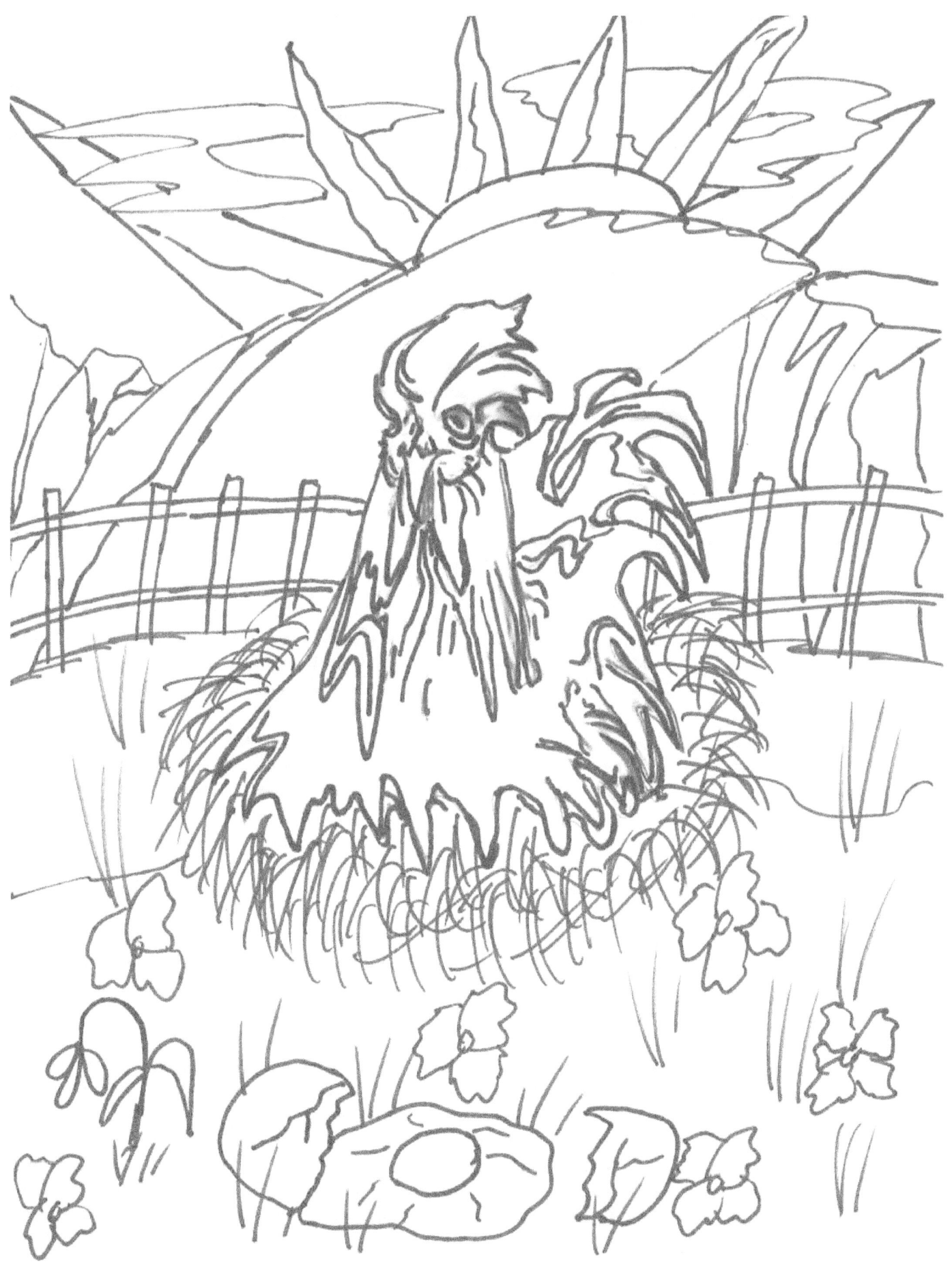

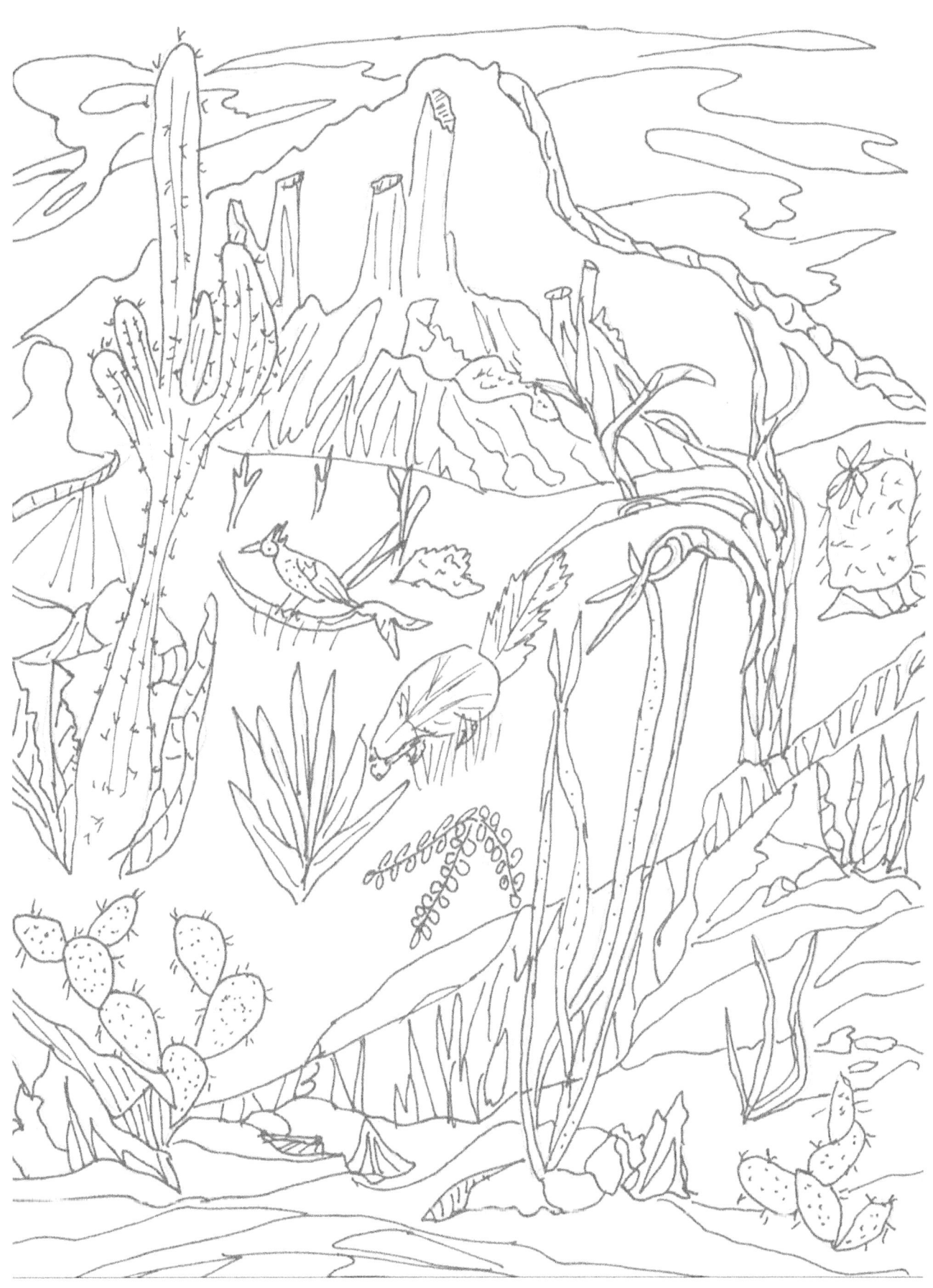

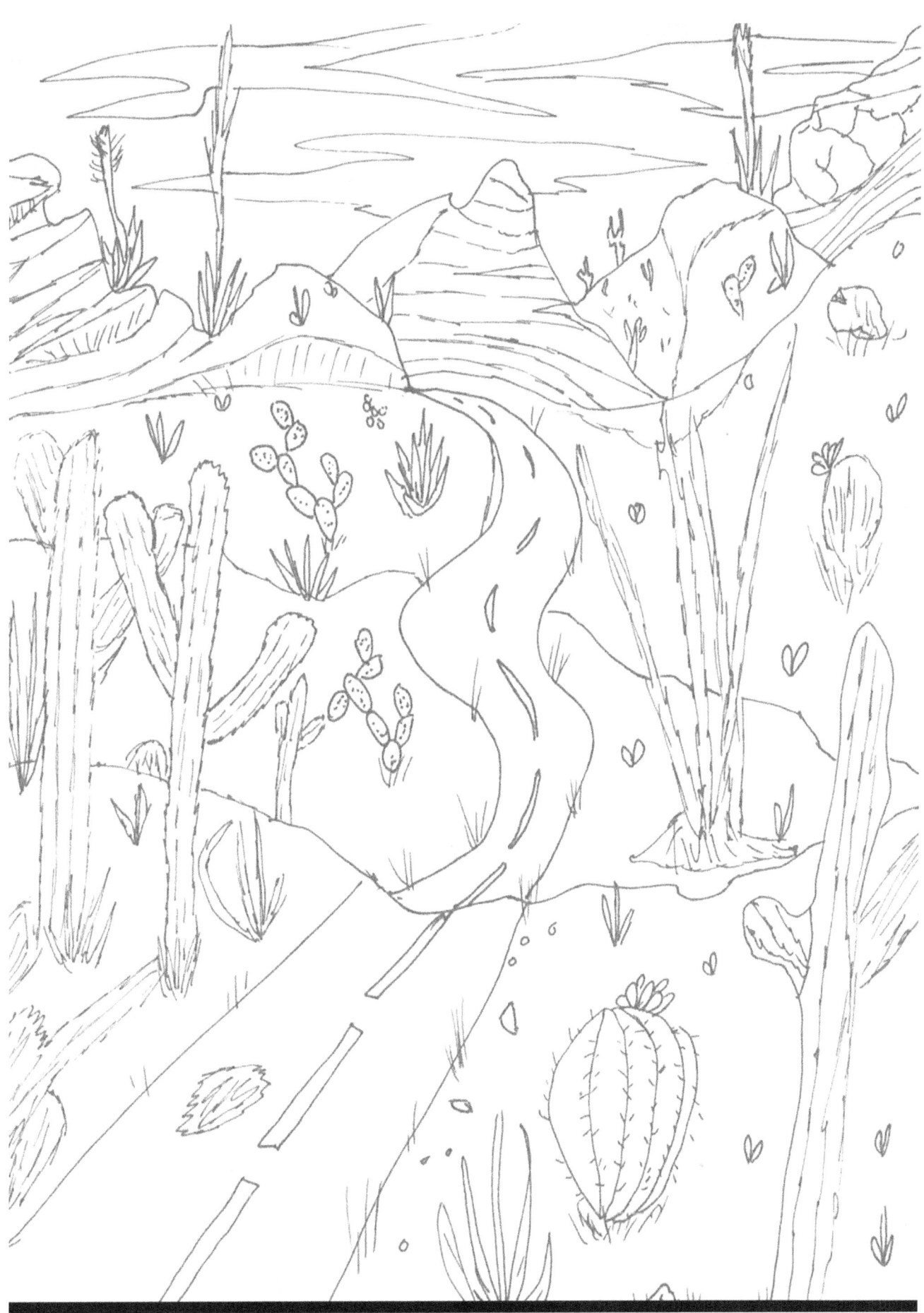

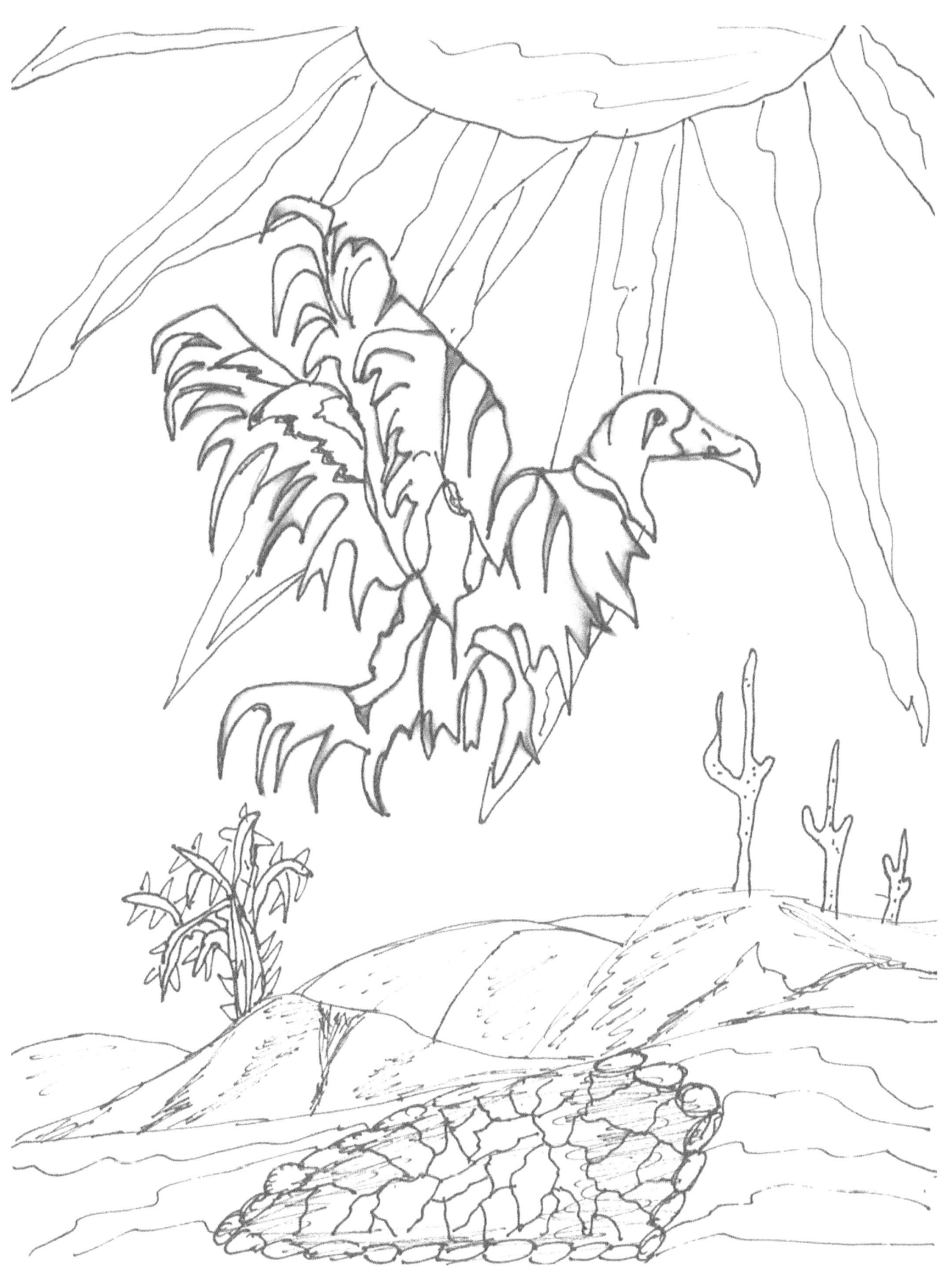

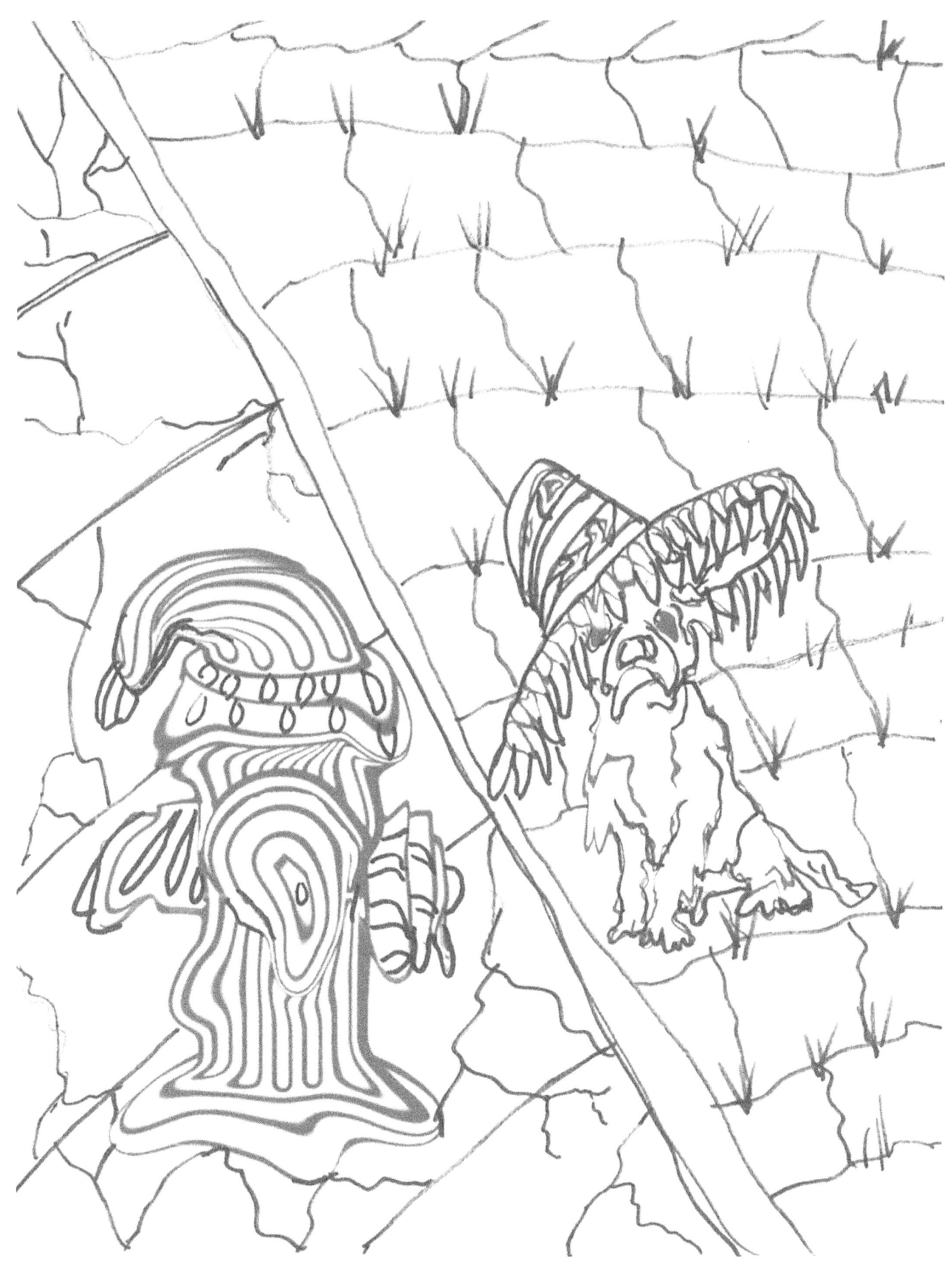

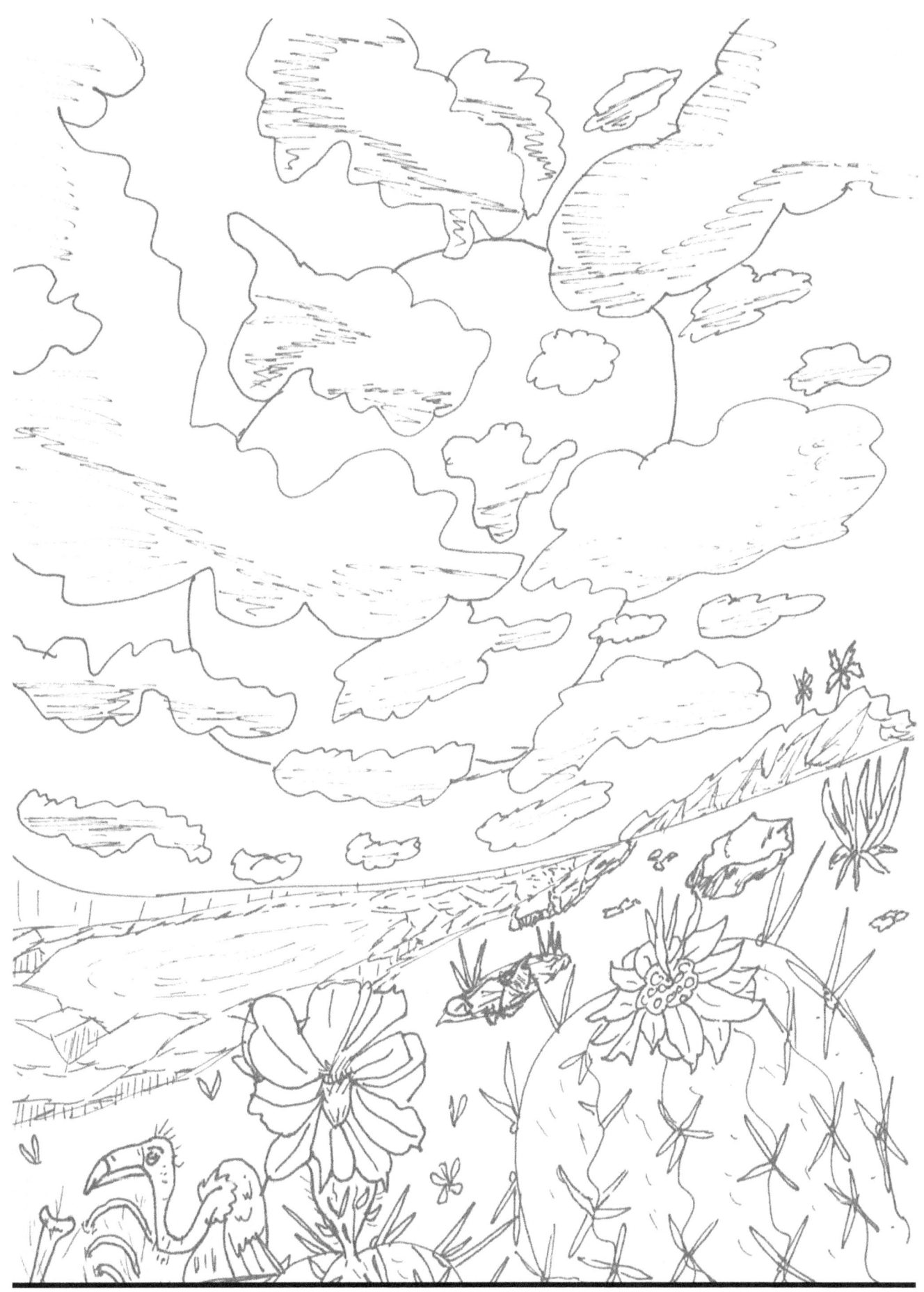

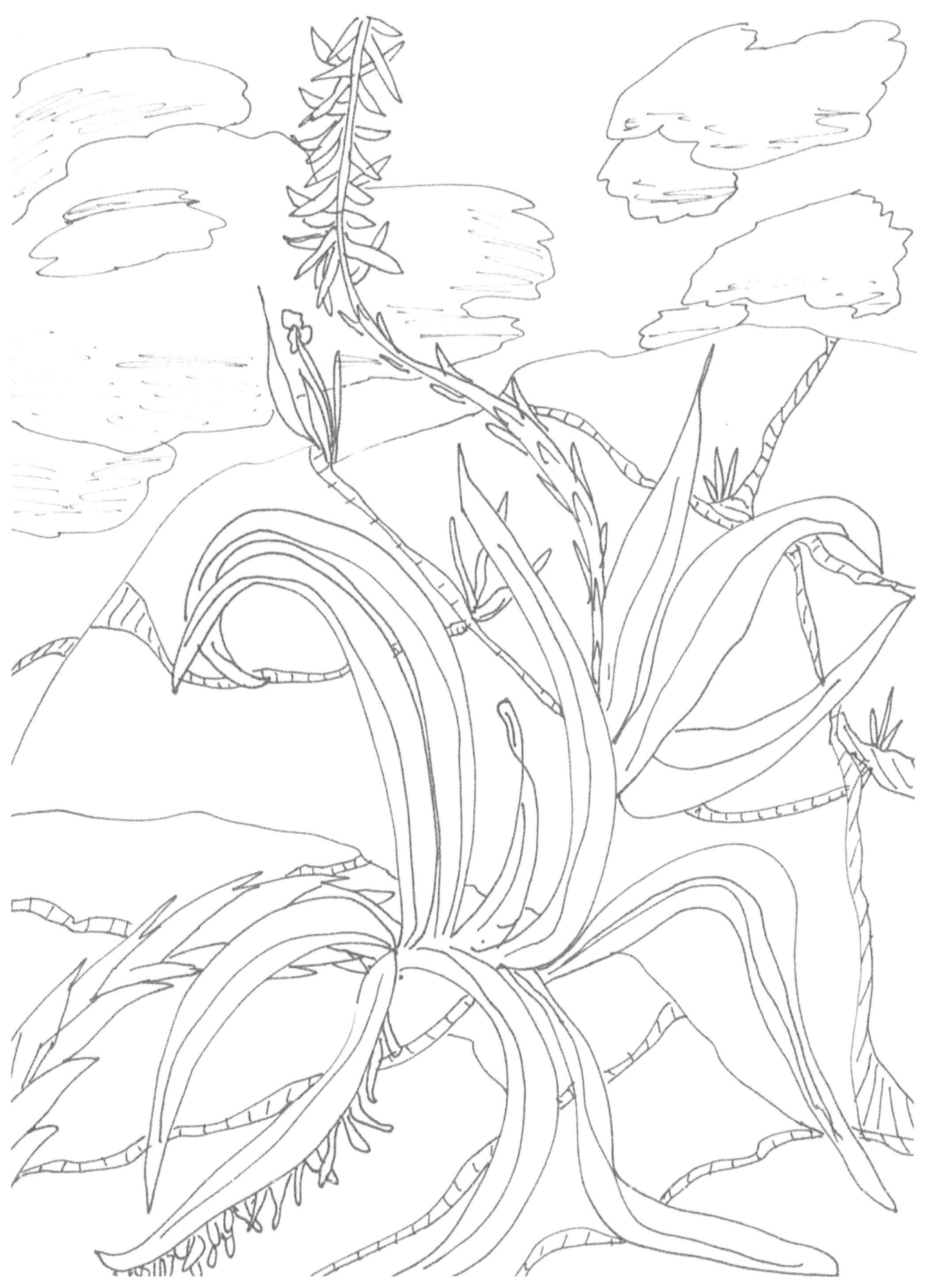

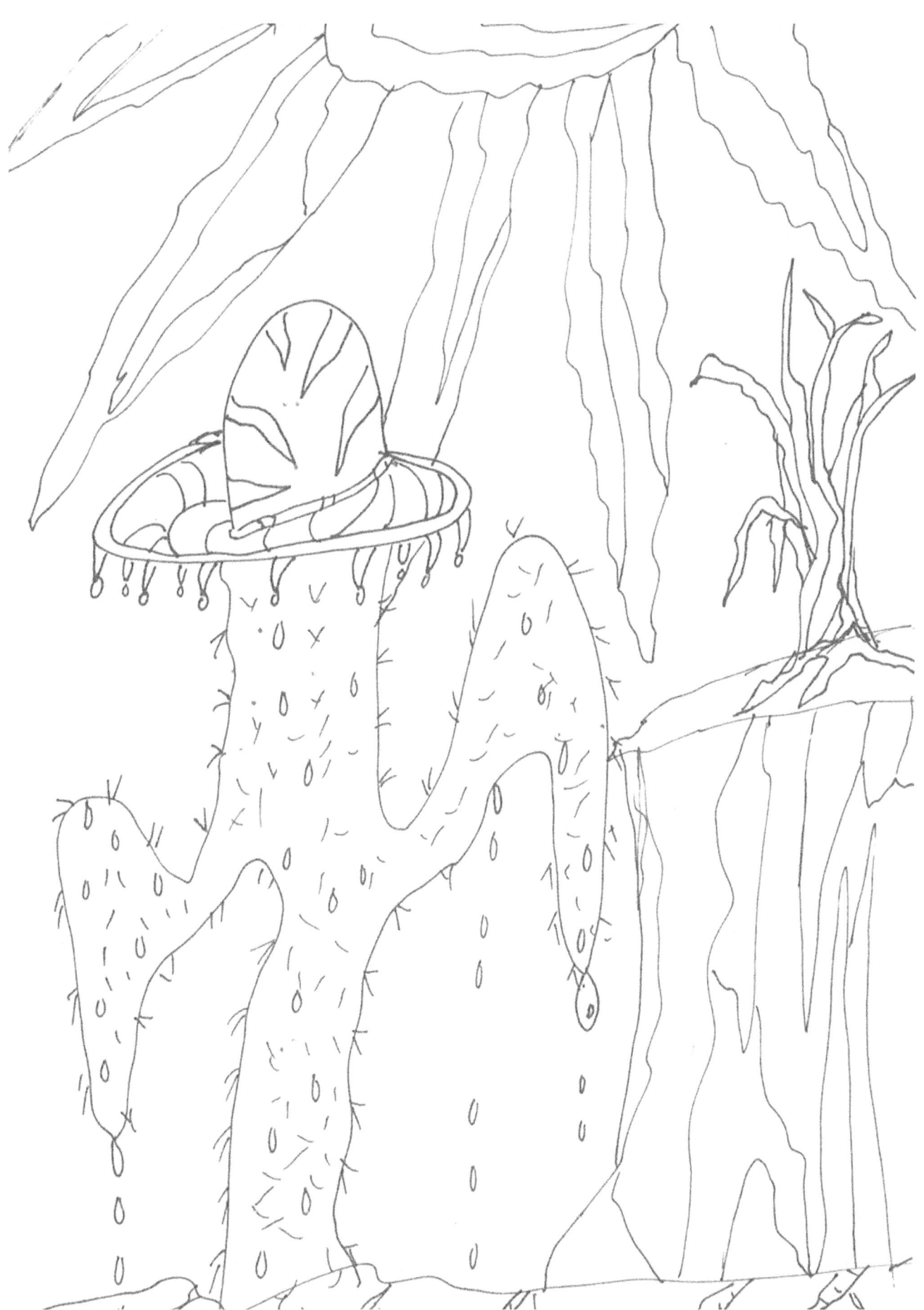

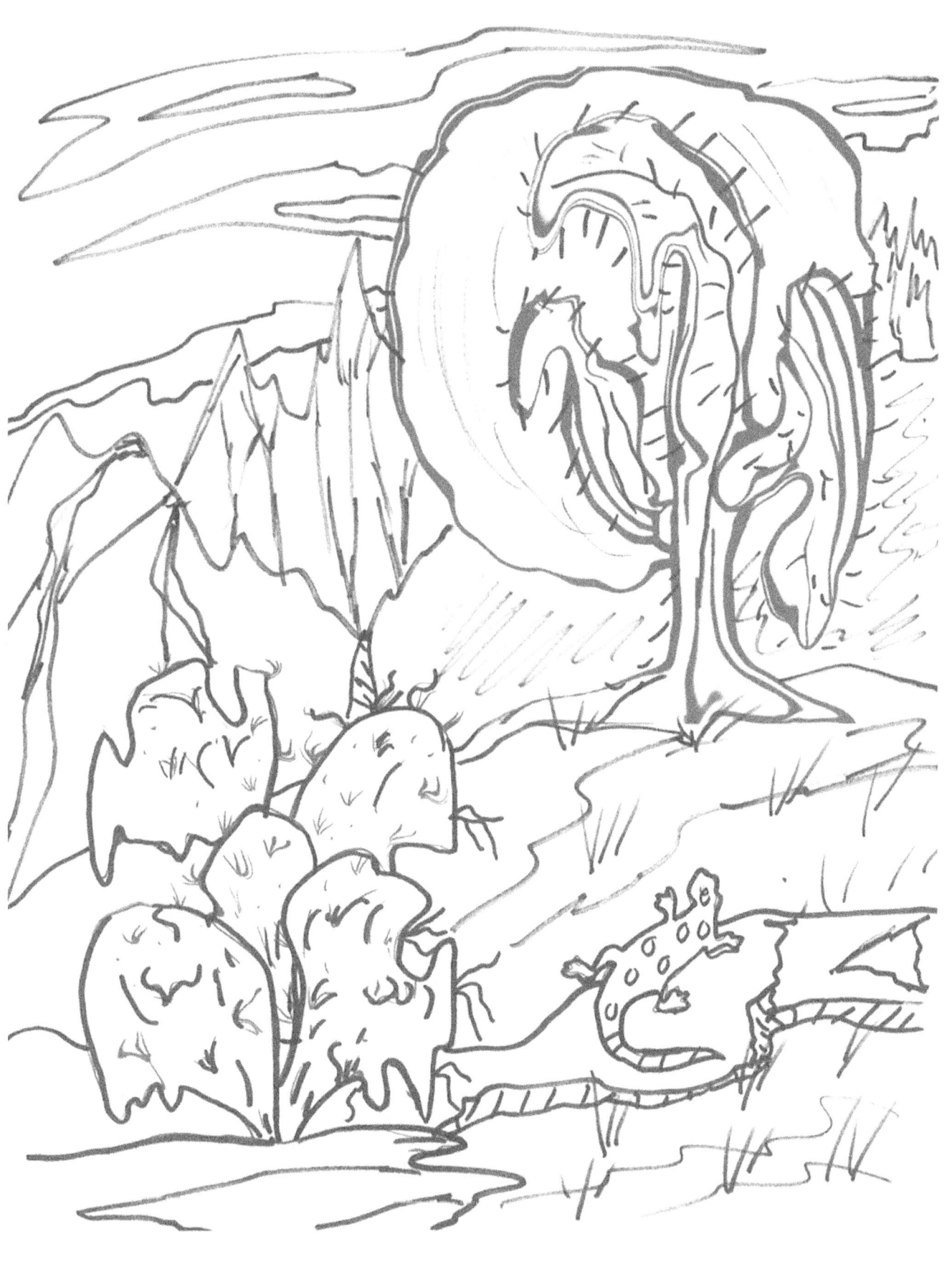

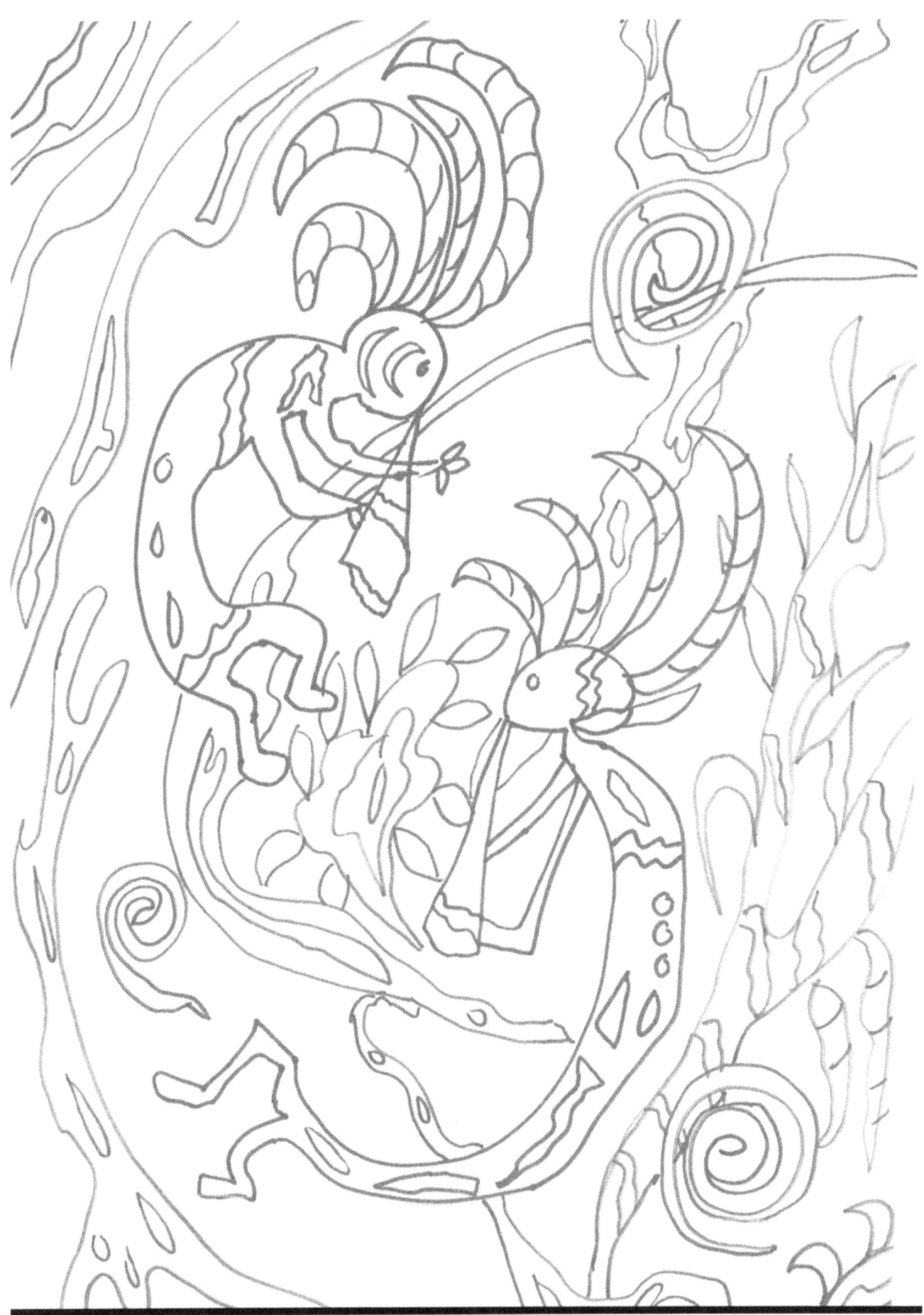

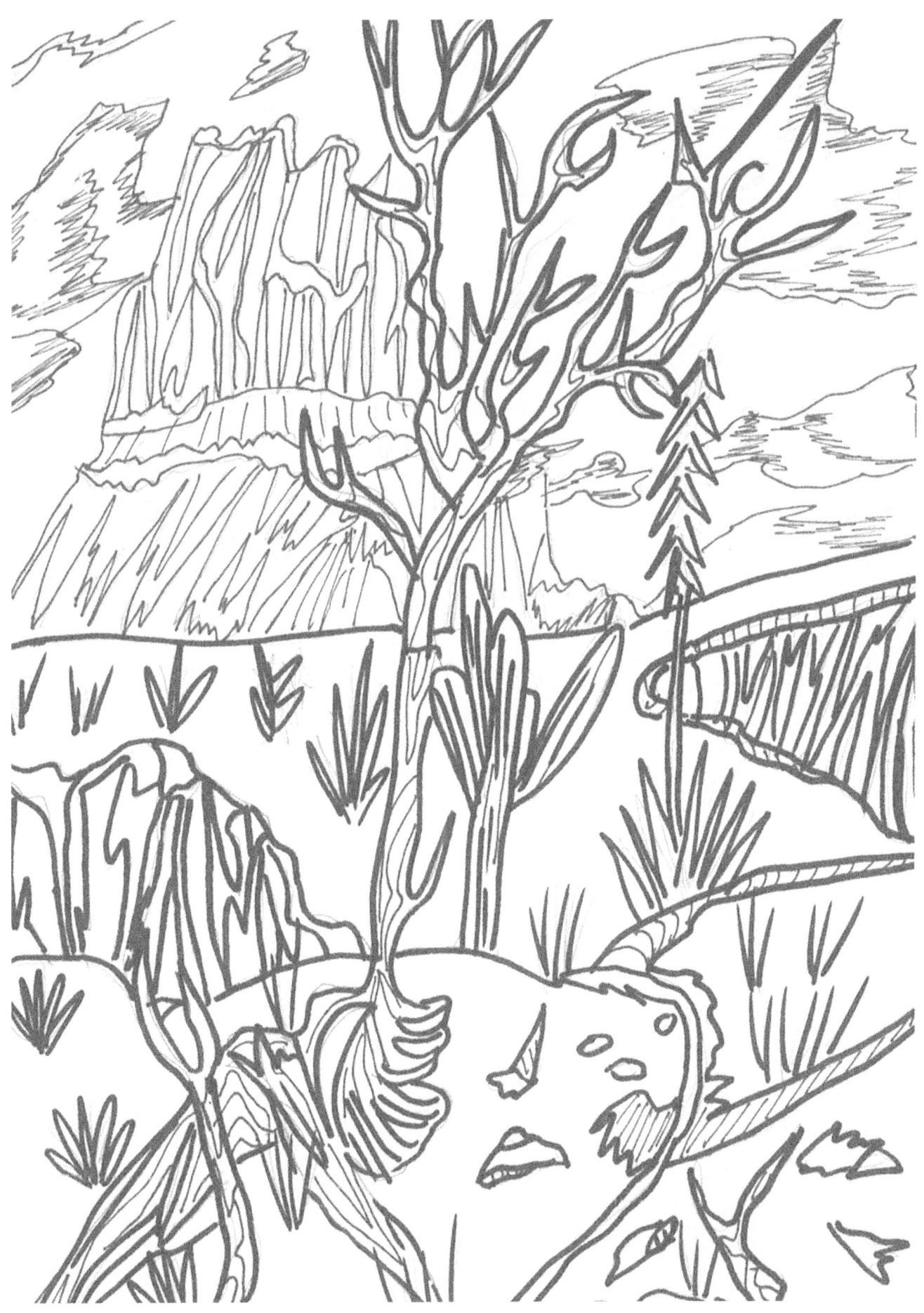

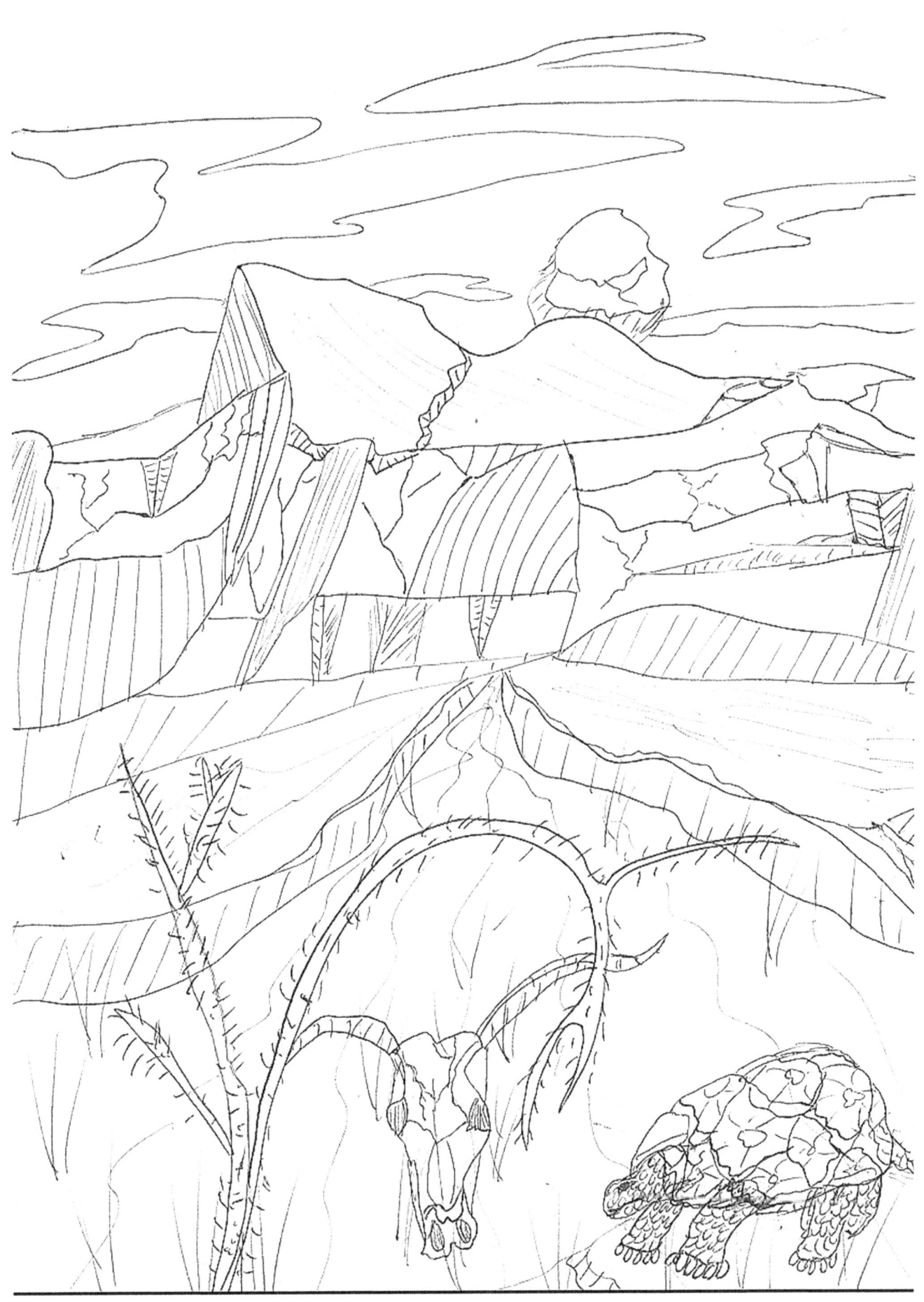

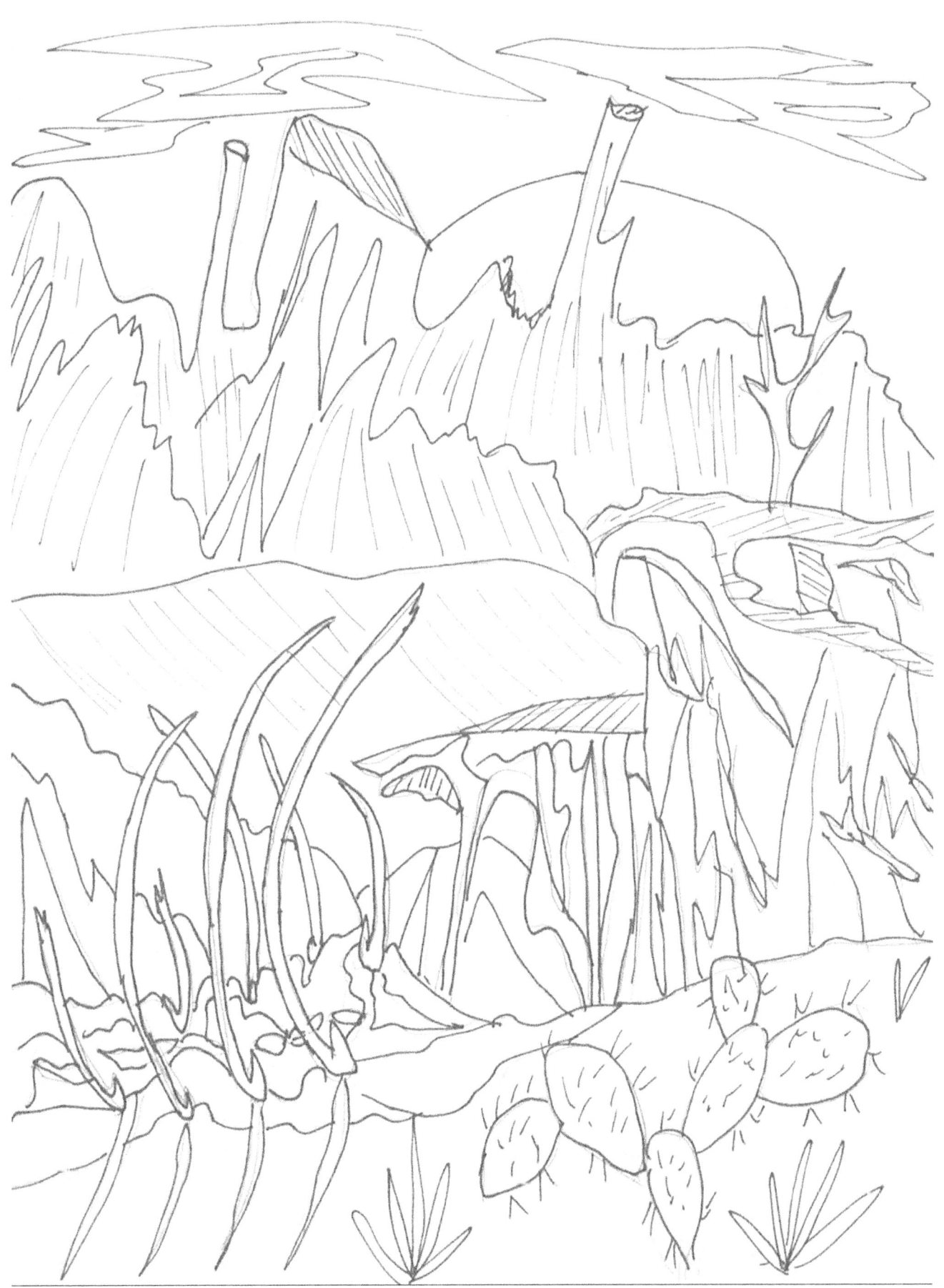

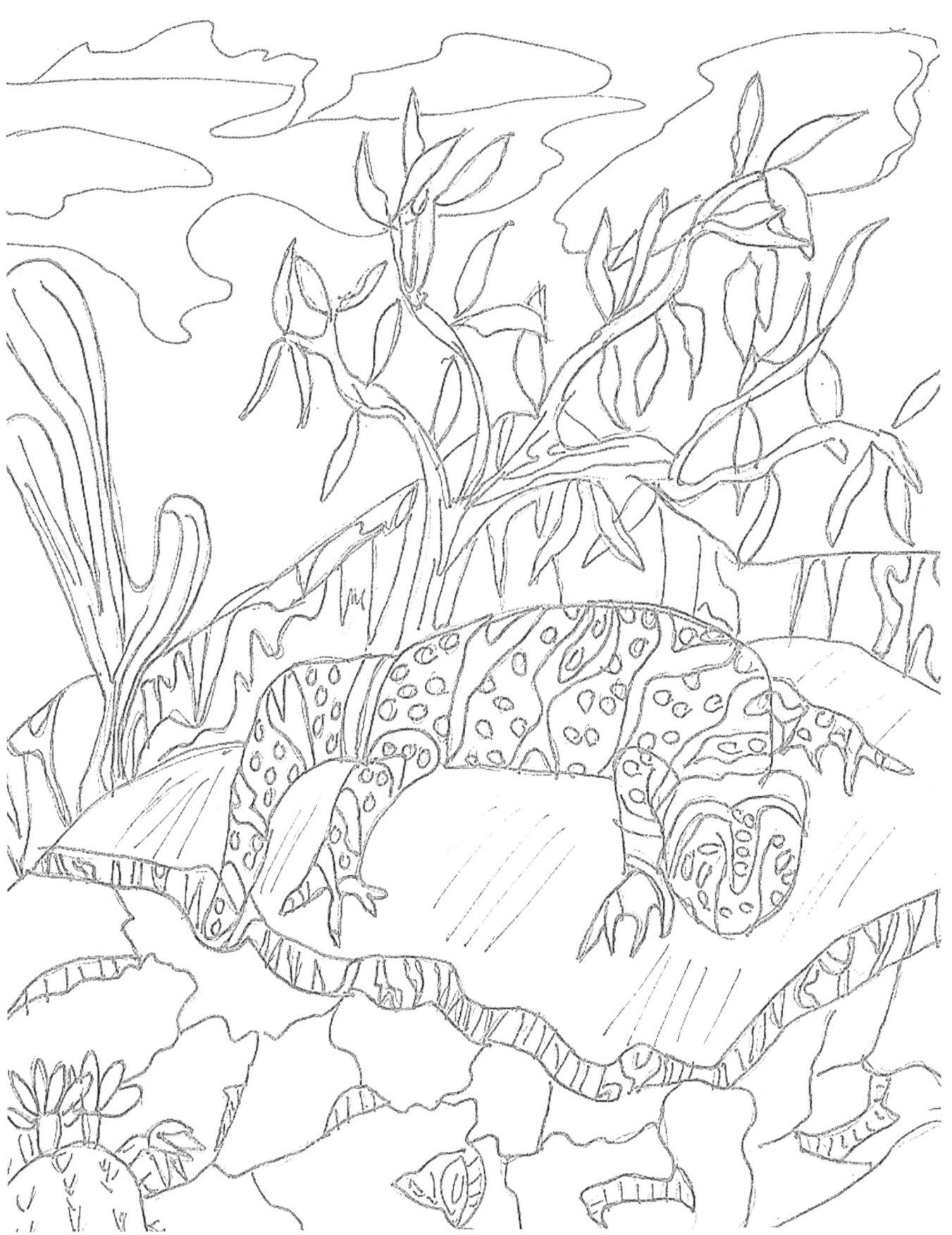

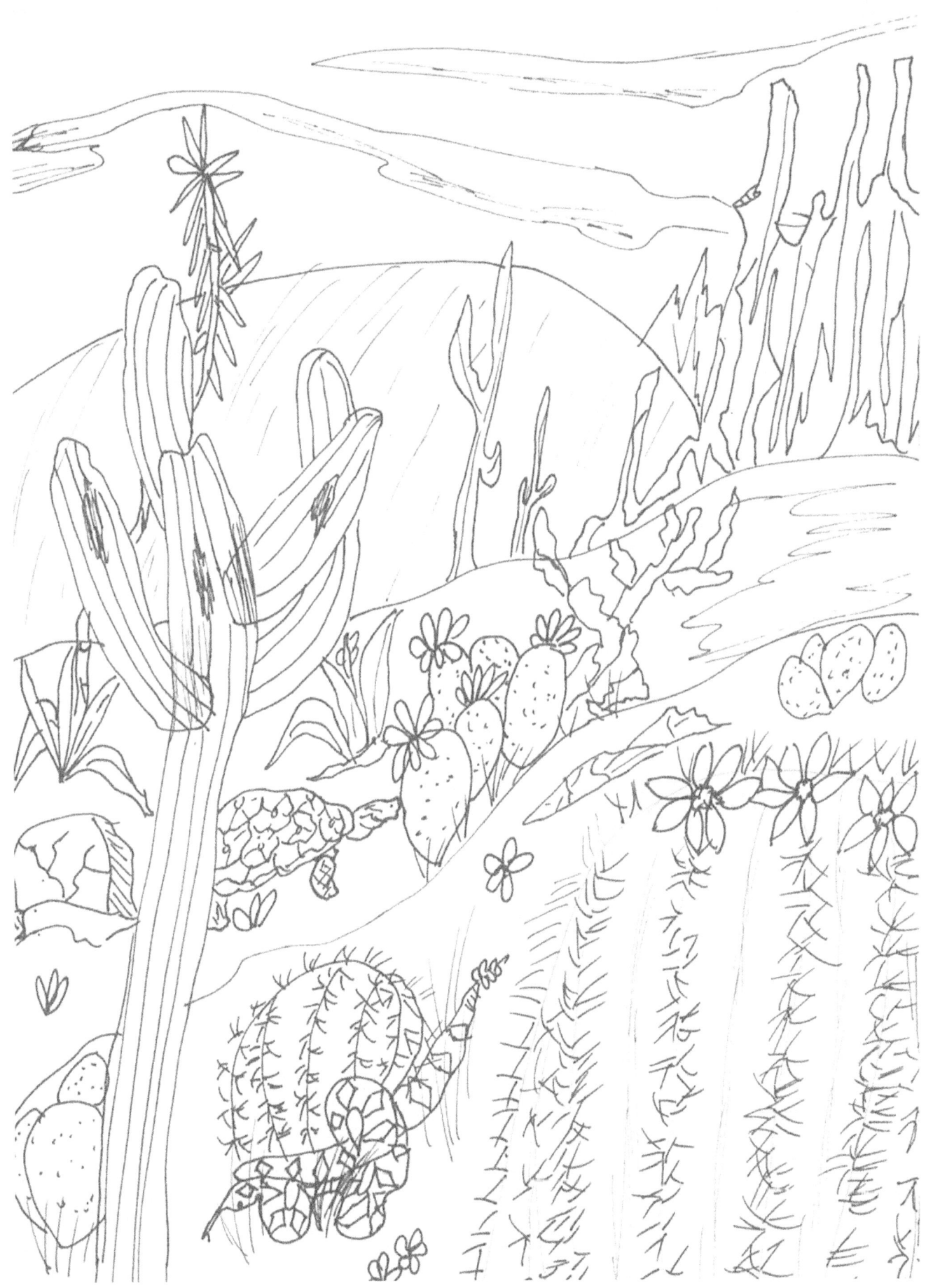

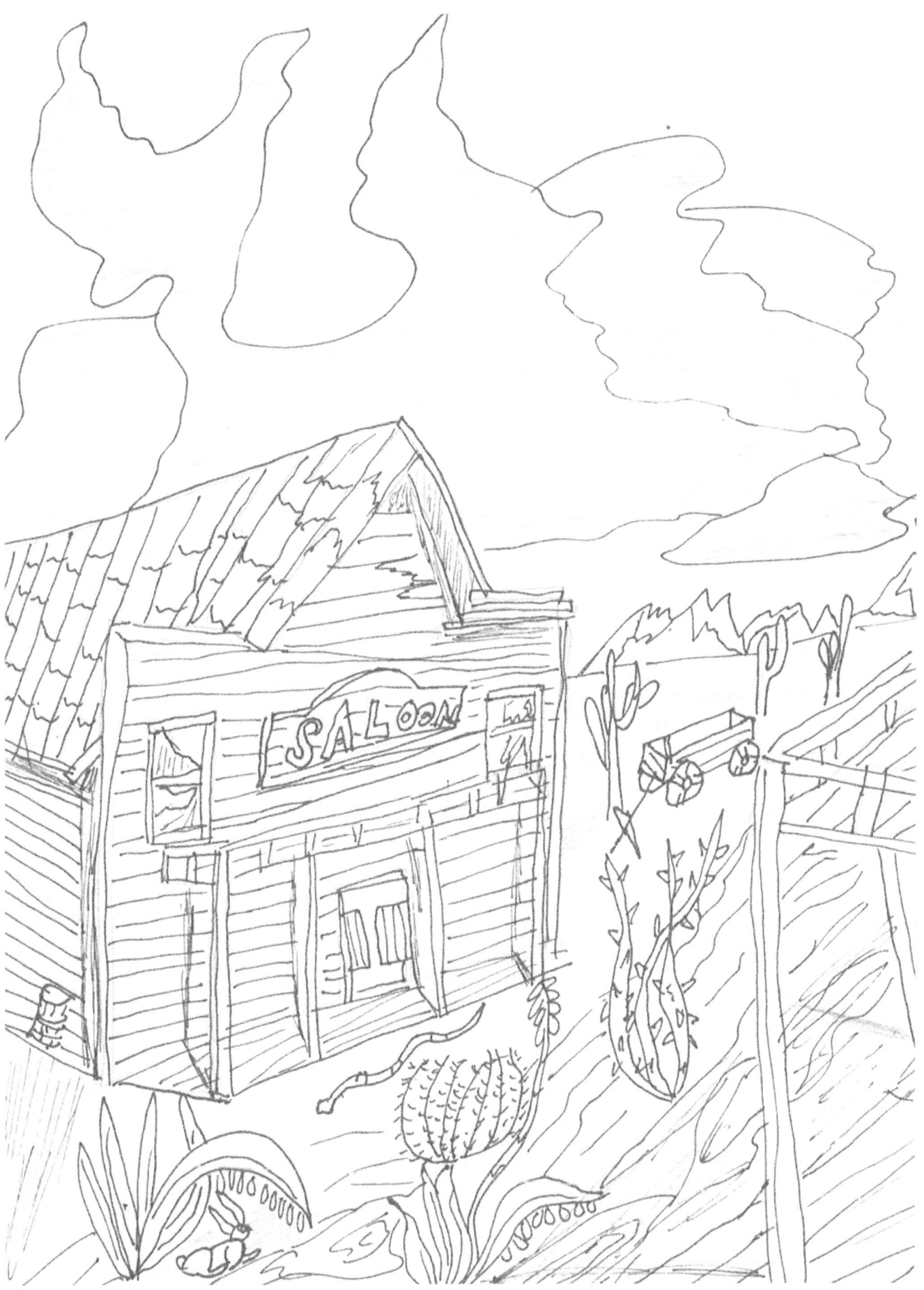

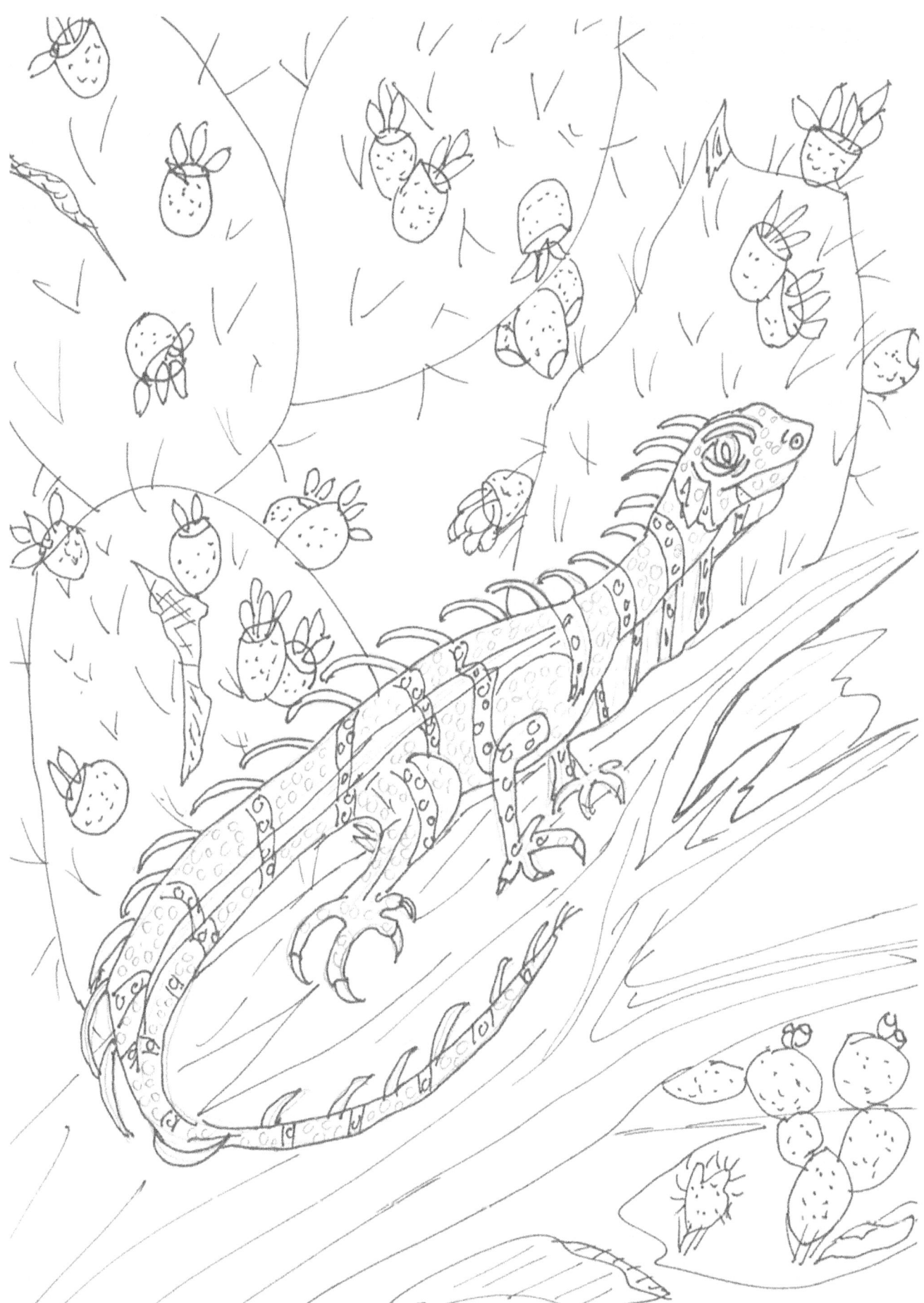

www.ingramcontent.com/pod-product-compliance
Lightning Source LLC
Chambersburg PA
CBHW080524190526
45169CB00008B/3050